How to Draw
Manga Faces

In Simple Steps

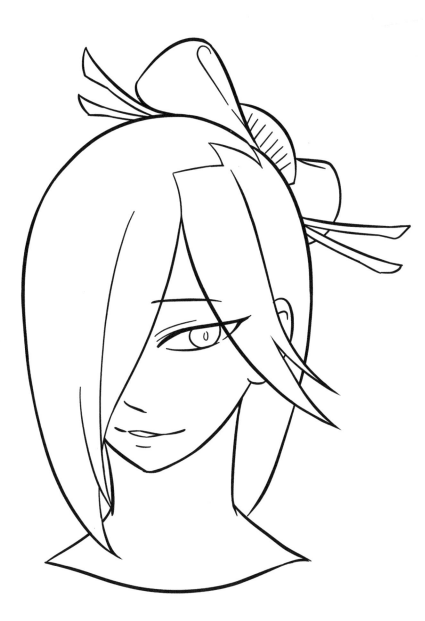

First published in 2023

Search Press Limited
Wellwood, North Farm Road,
Tunbridge Wells, Kent TN2 3DR

Text and illustrations copyright © Yishan Li, 2023

Design copyright © Search Press Ltd. 2023

ISBN: 978-1-80092-115-3
ebook ISBN: 978-1-80093-102-2

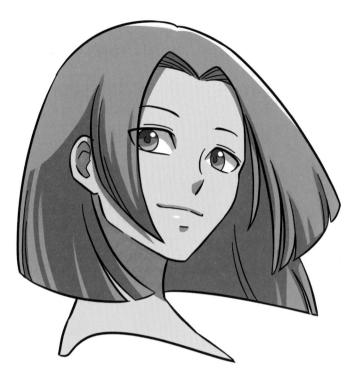

MIX
Paper | Supporting
responsible forestry
FSC® C012521
FSC www.fsc.org

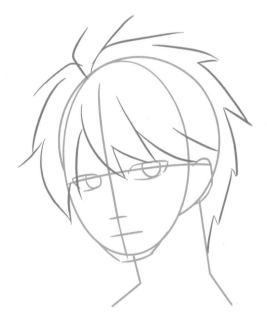

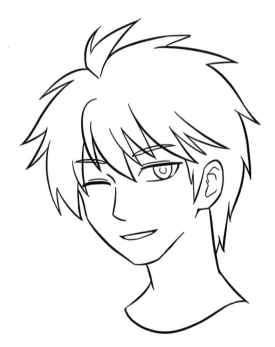

Illustrations

How to Draw
Manga Faces

In Simple Steps

Yishan Li

Search Press

Introduction

Drawing faces is always the starting point, and the most interesting part, of drawing a manga character. In this book, I start by drawing different types of eyes and mouths, then move onto drawing heads and hair. Each project has several steps to guide you through the whole drawing process.

The projects all start with very simple shapes, then gradually build up further shapes and details. I use different colours to indicate the new strokes added in each step. The first shape is always in blue, then new shapes added are in pink; after that, the black lines are used to draw the image itself, then the final image is fully coloured to show you the completed picture.

When you practise, all you need is paper, a pencil and an eraser. I prefer normal copying paper to special art paper, because it's cheaper and easy to draw on. You can choose any soft graphite pencil you like, preferably a 2B. It is fine to use the eraser you normally use at home, work or school.

When drawing the initial shapes, start with very light strokes, then when adding more details, you can use a slightly more solid line. This way you can see your final image clearly rather than burying it under lots of messy lines.

Once you are more confident with your pencil drawings, you can add inking and colours. What you need is an inking pen and colouring materials. The inking pen can be any black waterproof gel pen. Try it first on a spare piece of paper to make sure it doesn't smudge, then go over your main pencil image. When you are happy with this inked image, you can clear away all the pencil lines with the eraser. For colouring pens, I prefer water-based dye ink pens, but if you prefer something easily available at home, you can also use watercolour or coloured pencils.

The most important thing I hope you learn from this book is to be creative. You can combine the various features, heads and hair to create your own manga characters. You can also change their expressions to make your drawings unique.

Happy drawing!

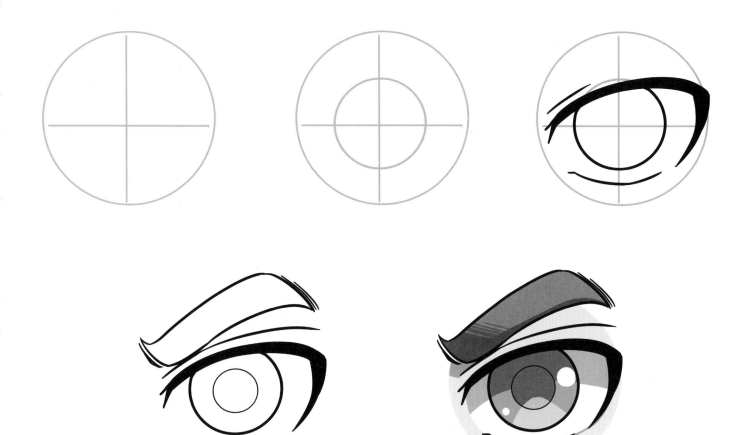

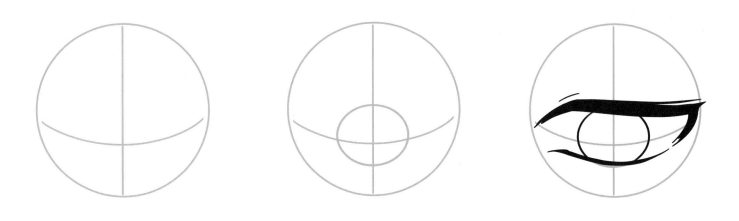

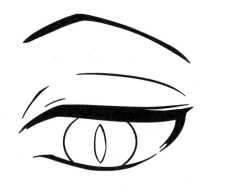

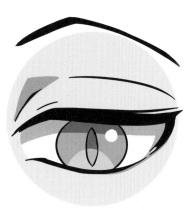

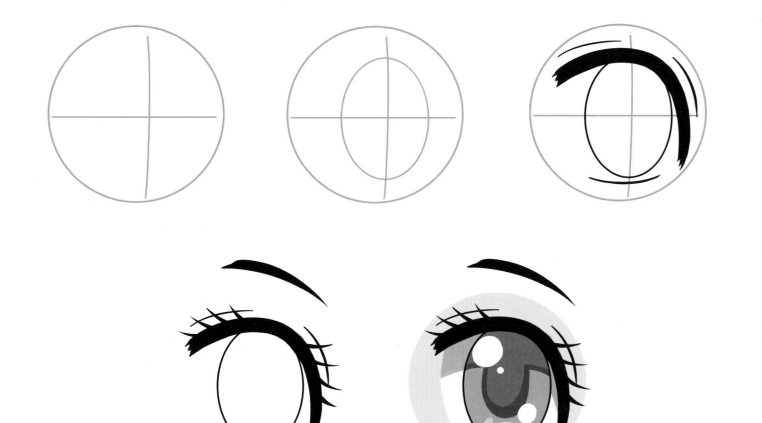

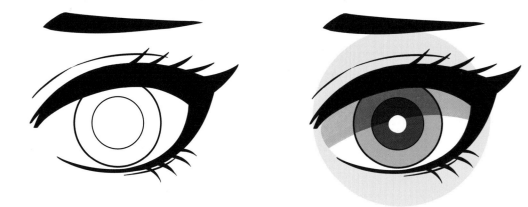

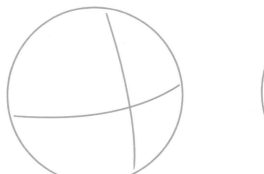
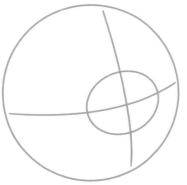
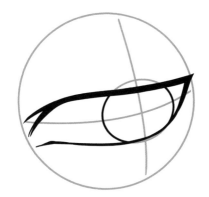

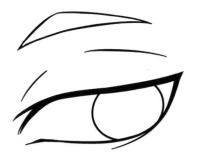
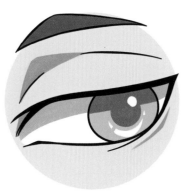

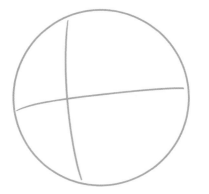
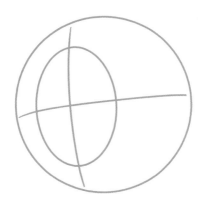

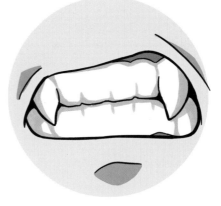

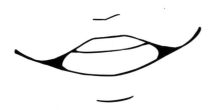
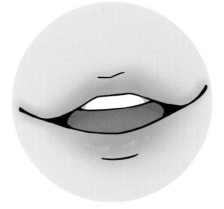

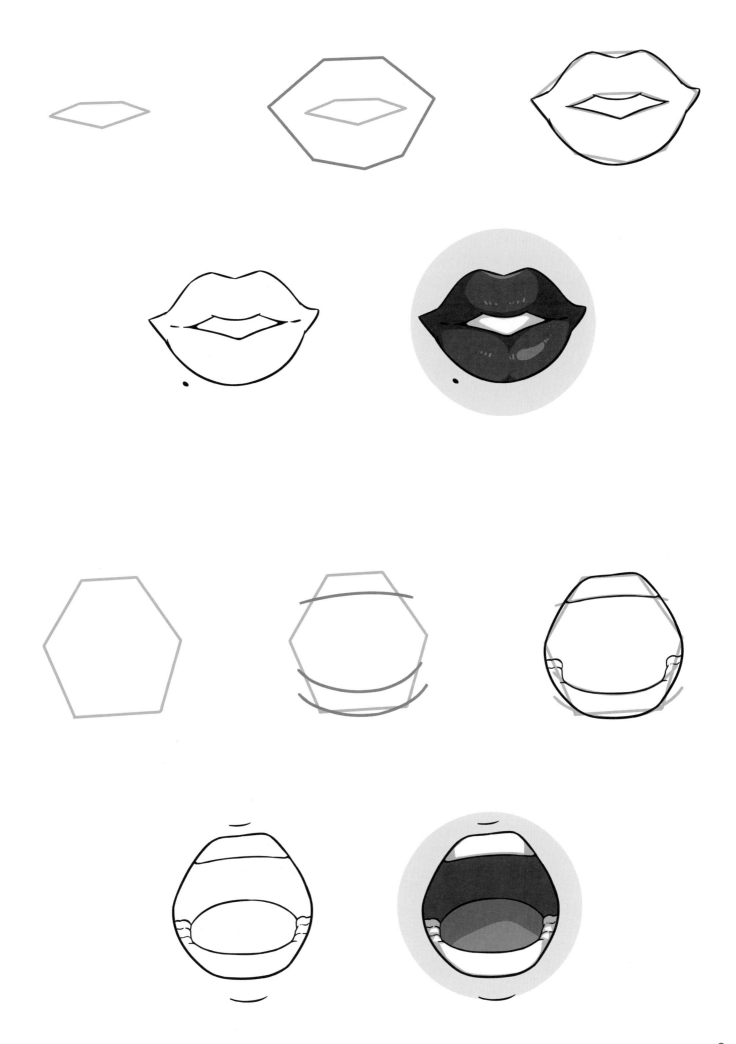

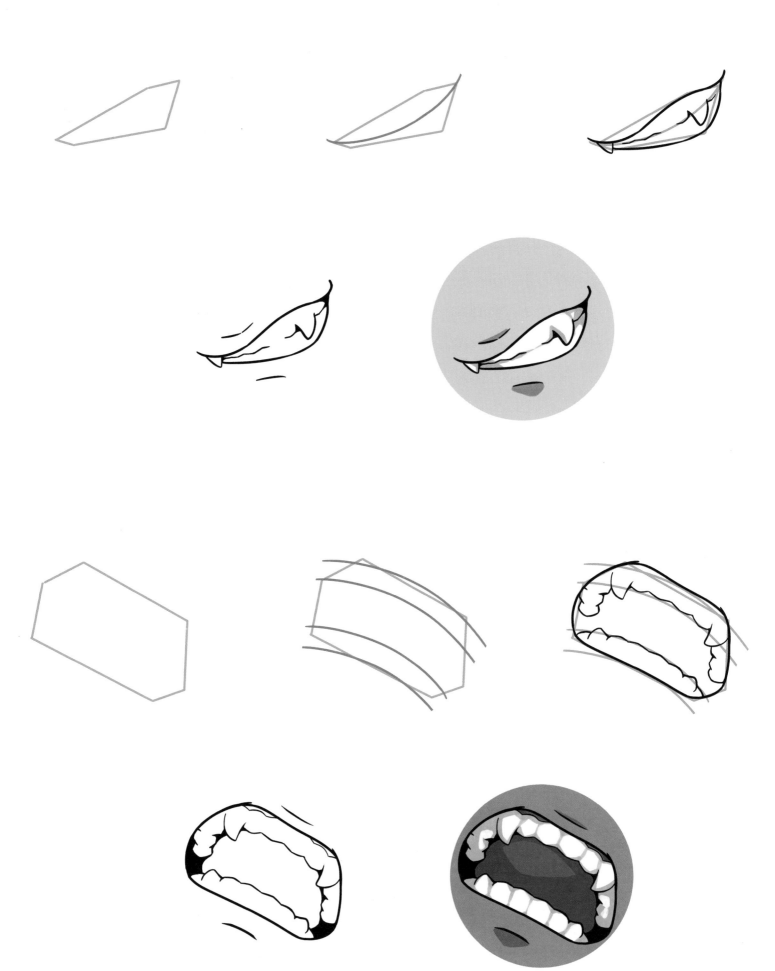

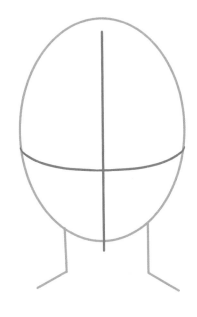
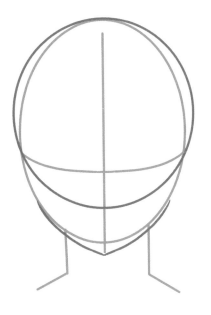
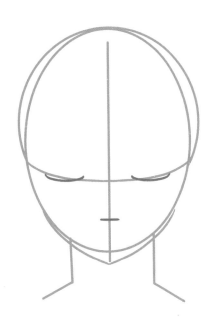
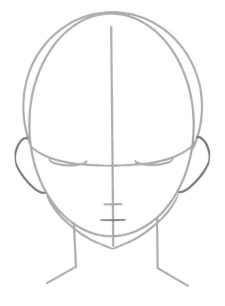
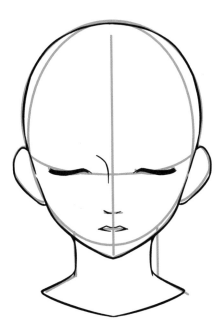
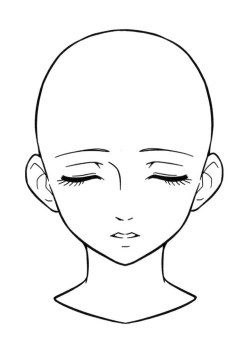
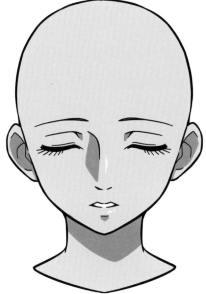

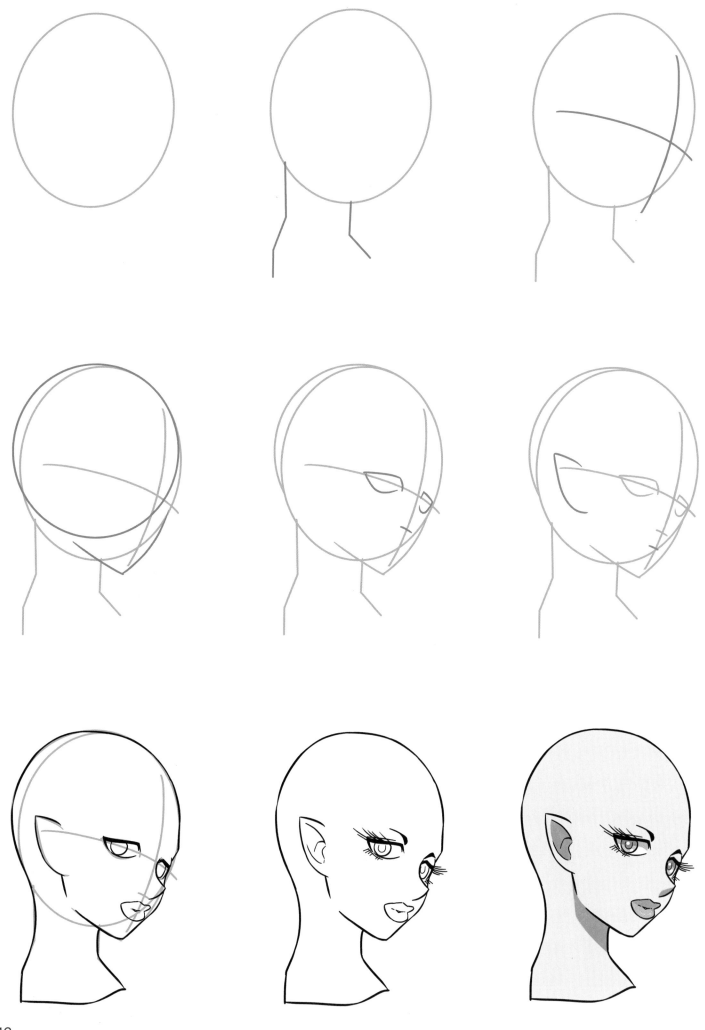

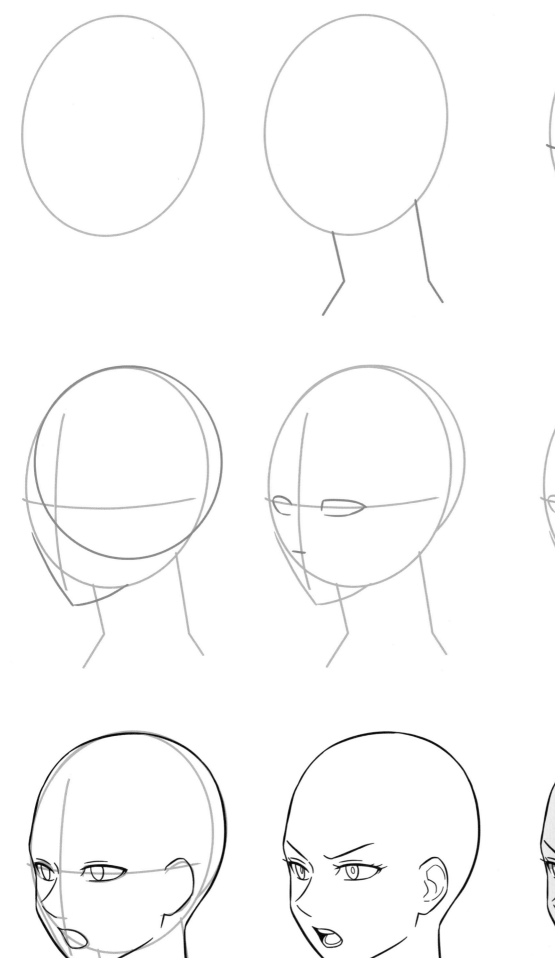

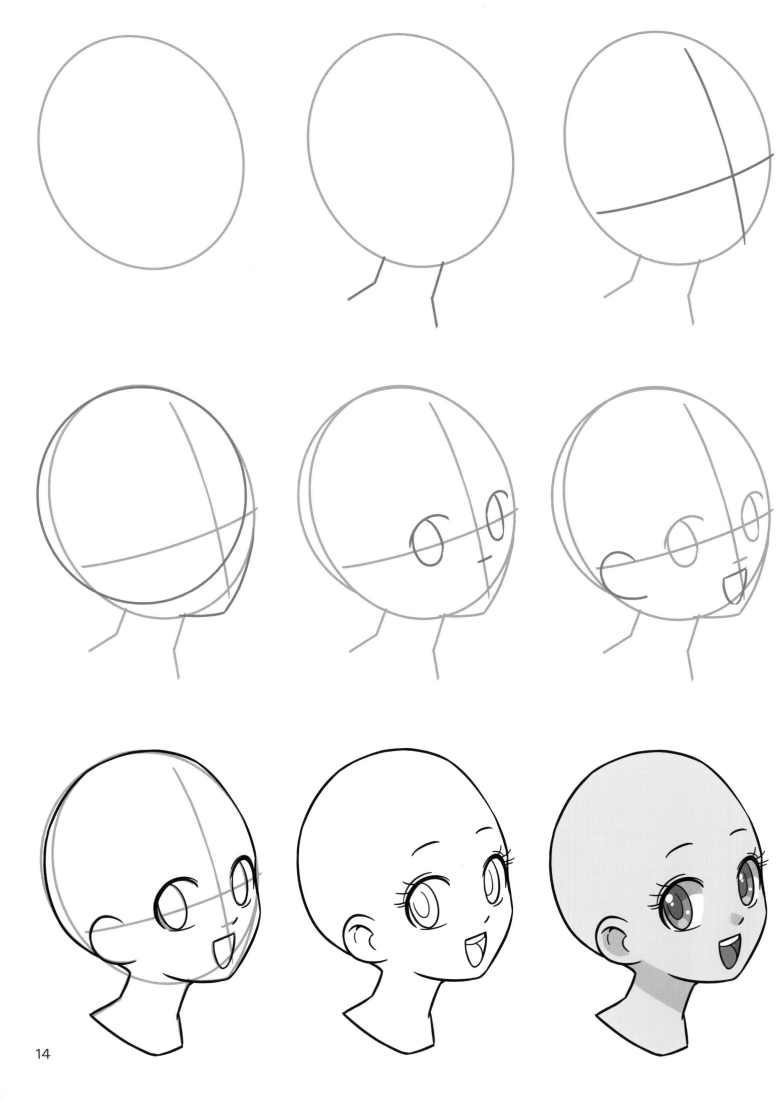

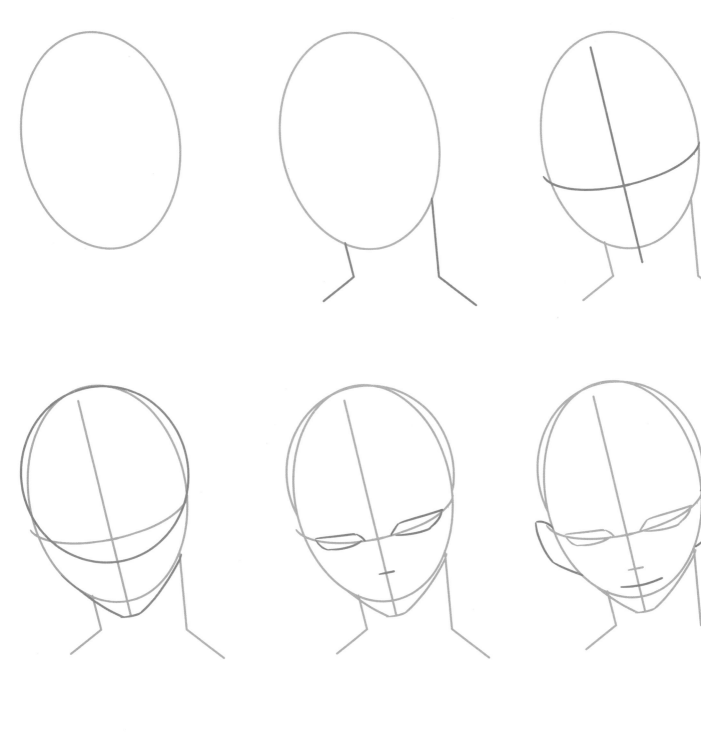
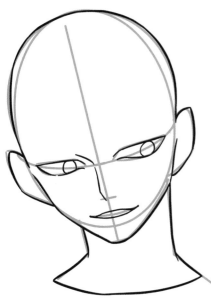
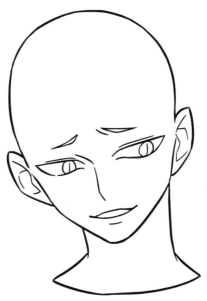
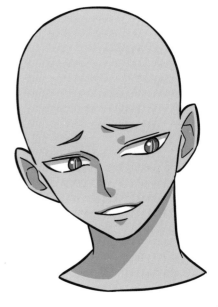

15

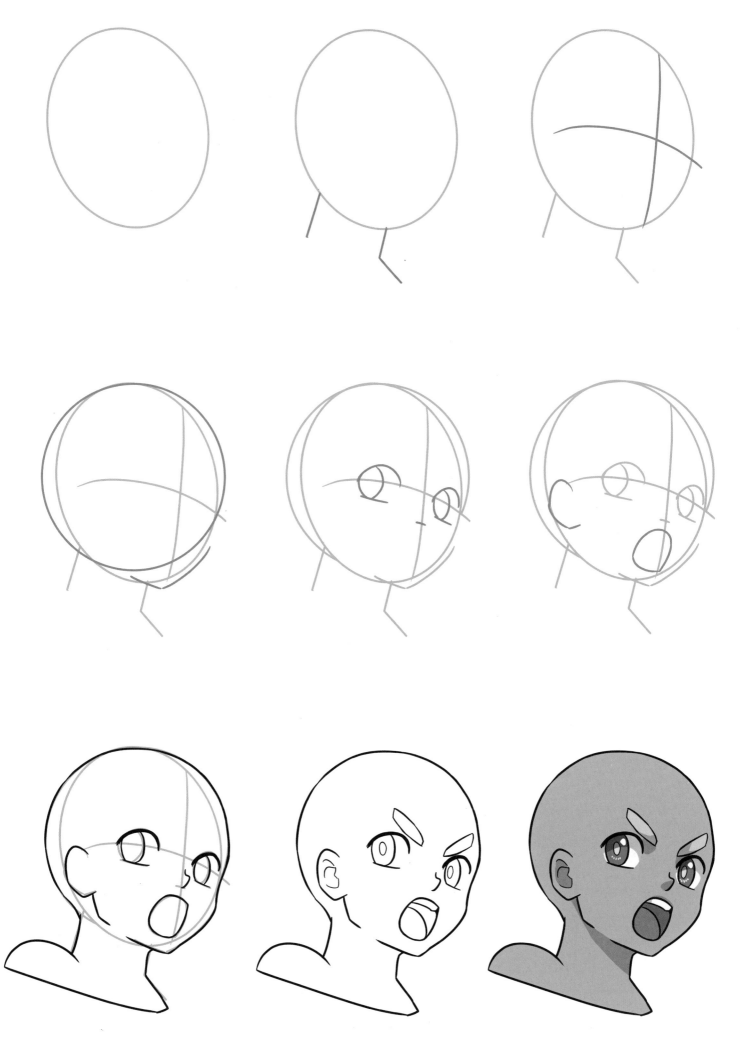

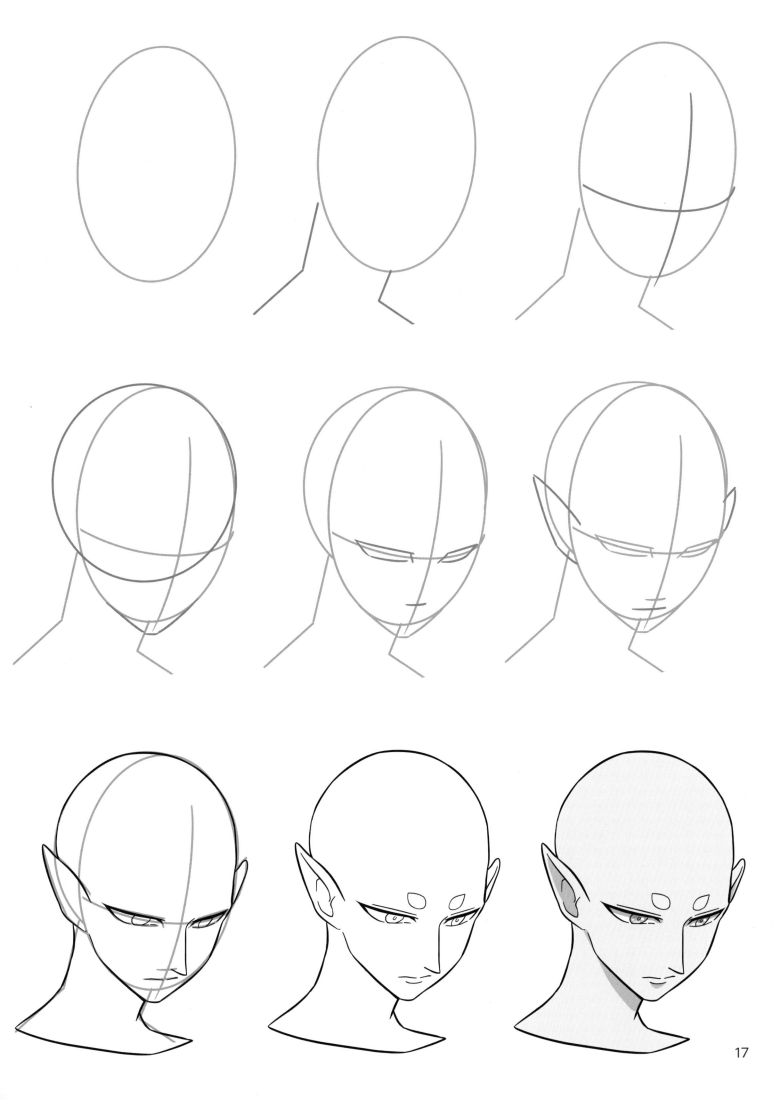

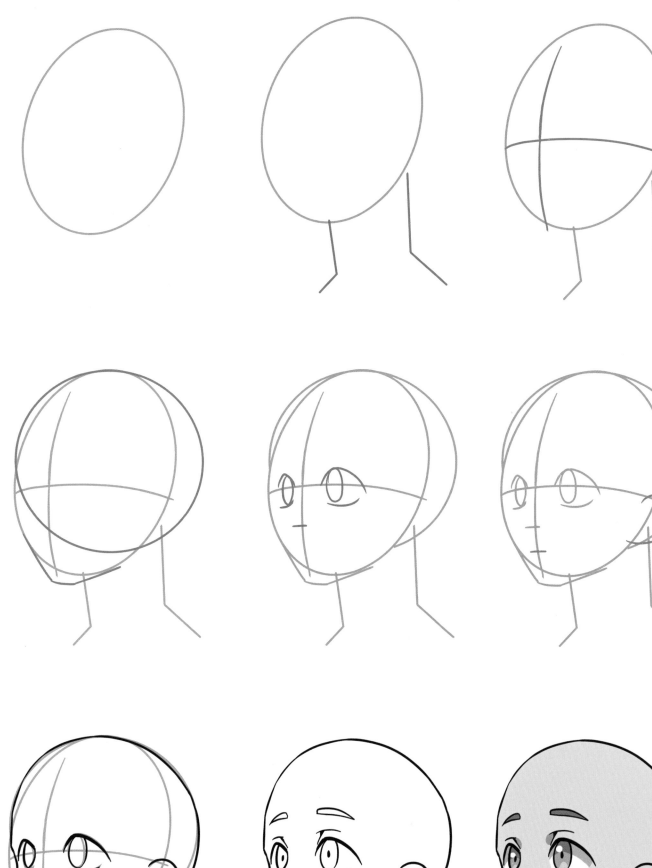
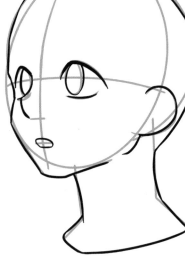
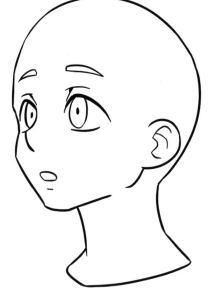
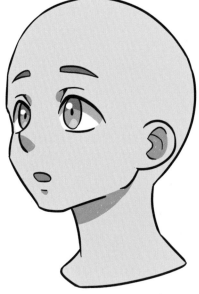

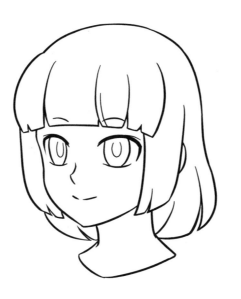
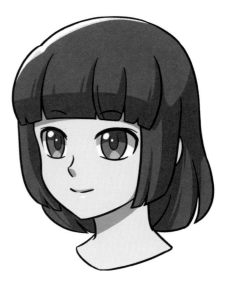

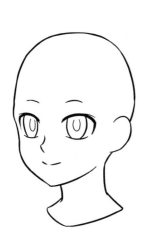
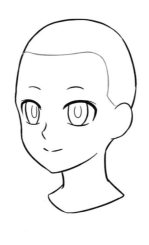
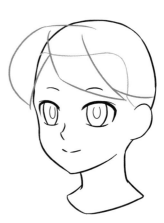

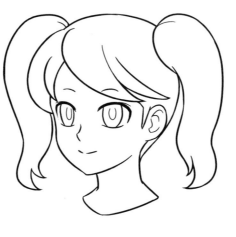
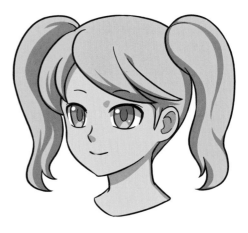

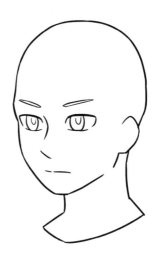
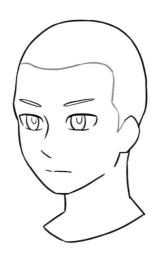

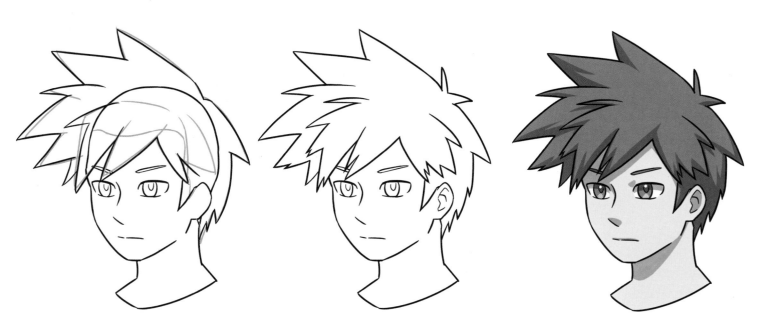

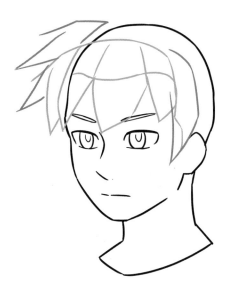
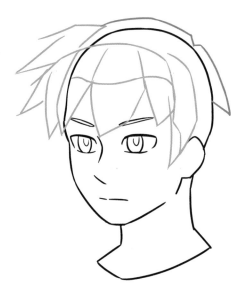
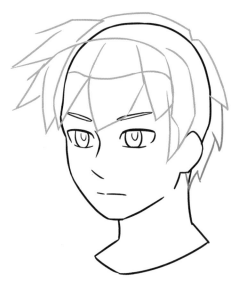
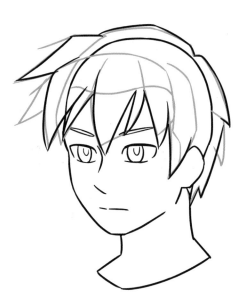
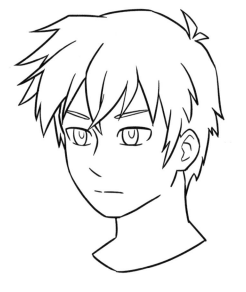
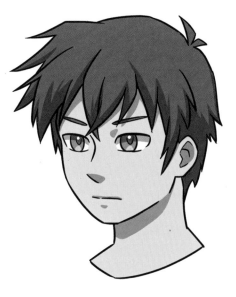

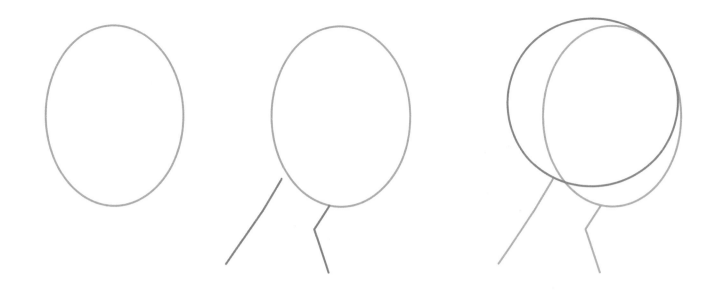

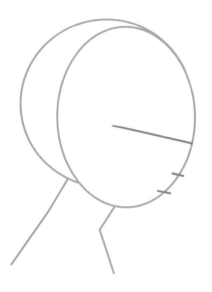 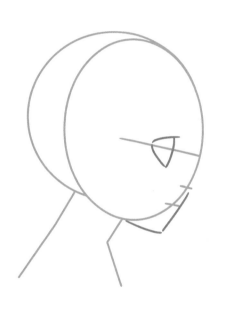 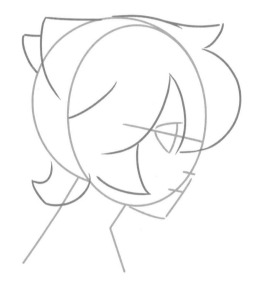

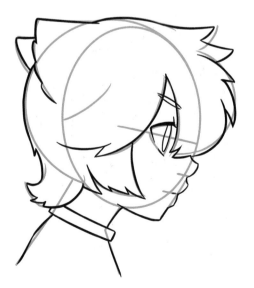 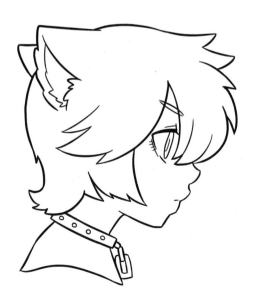 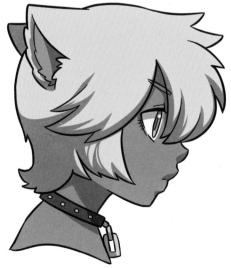

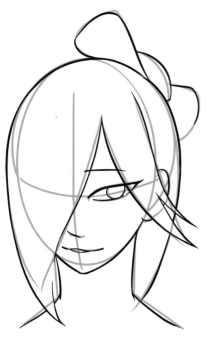
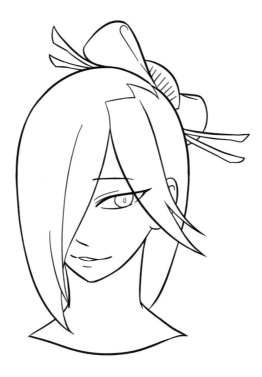
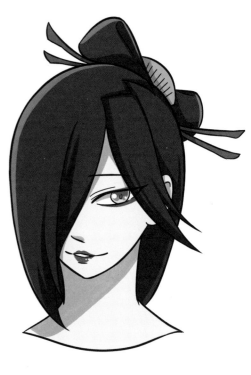

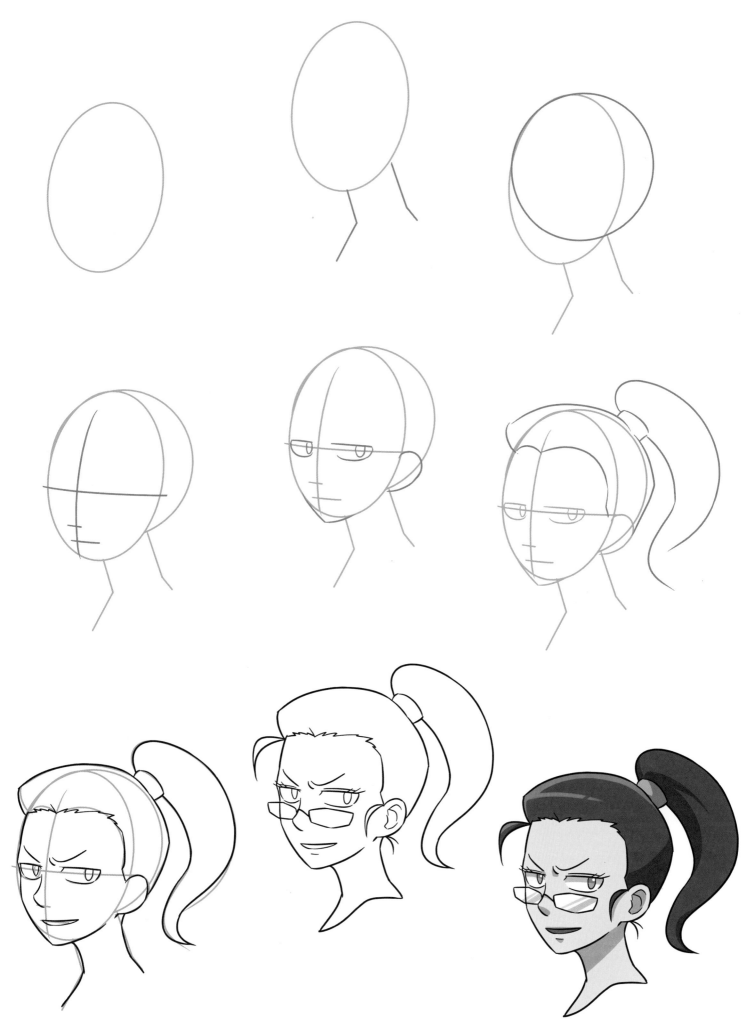

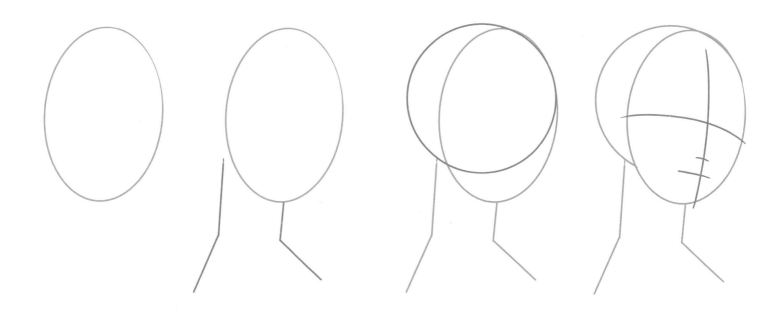

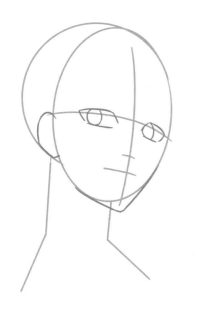 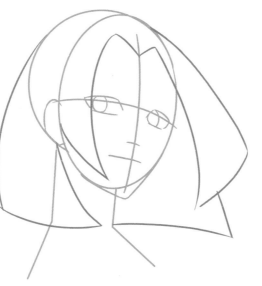 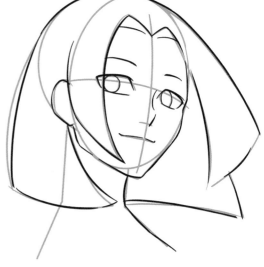

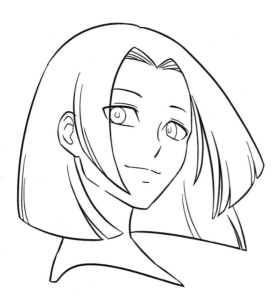 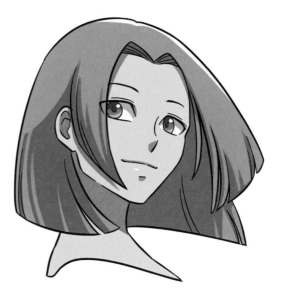

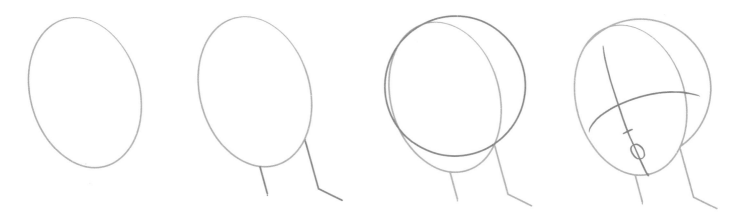

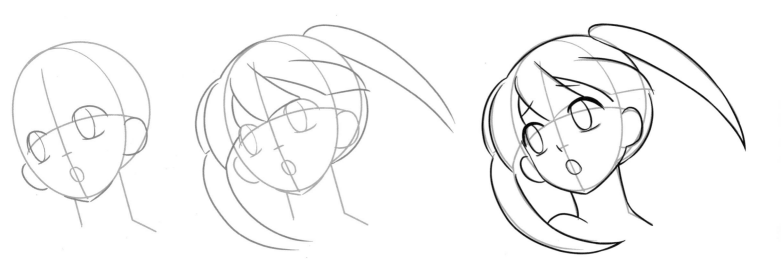

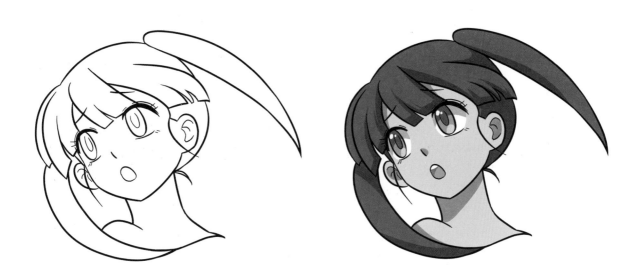

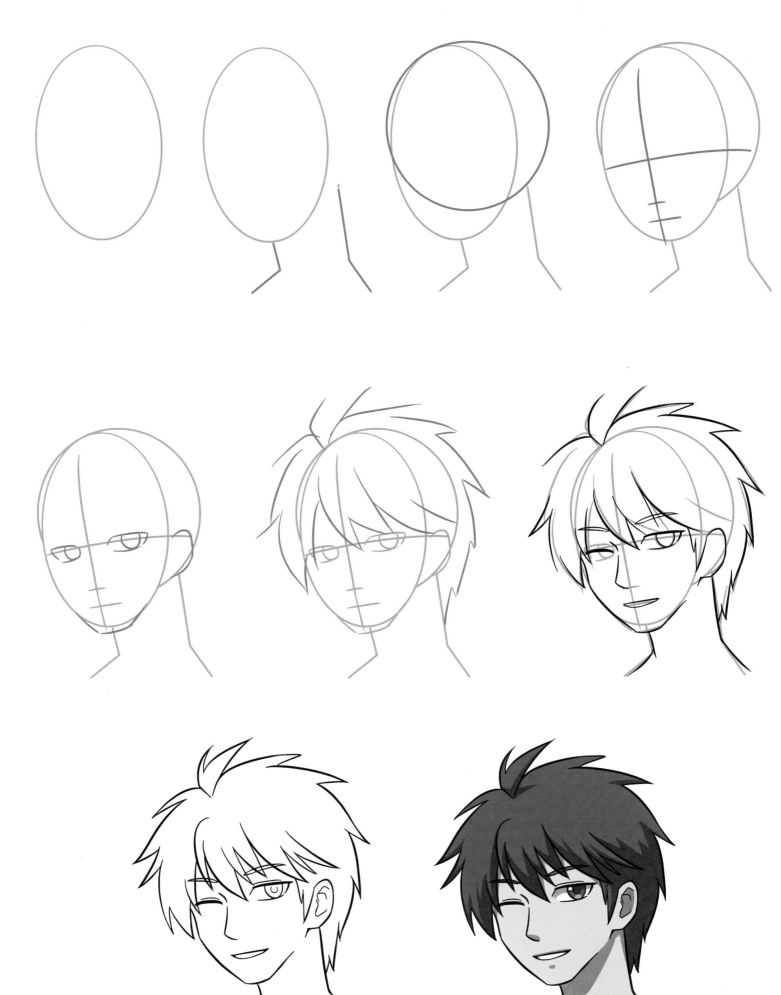

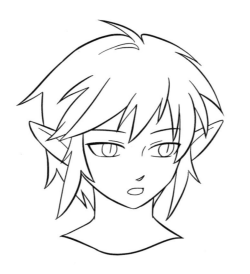
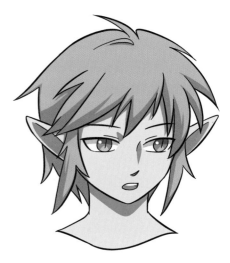

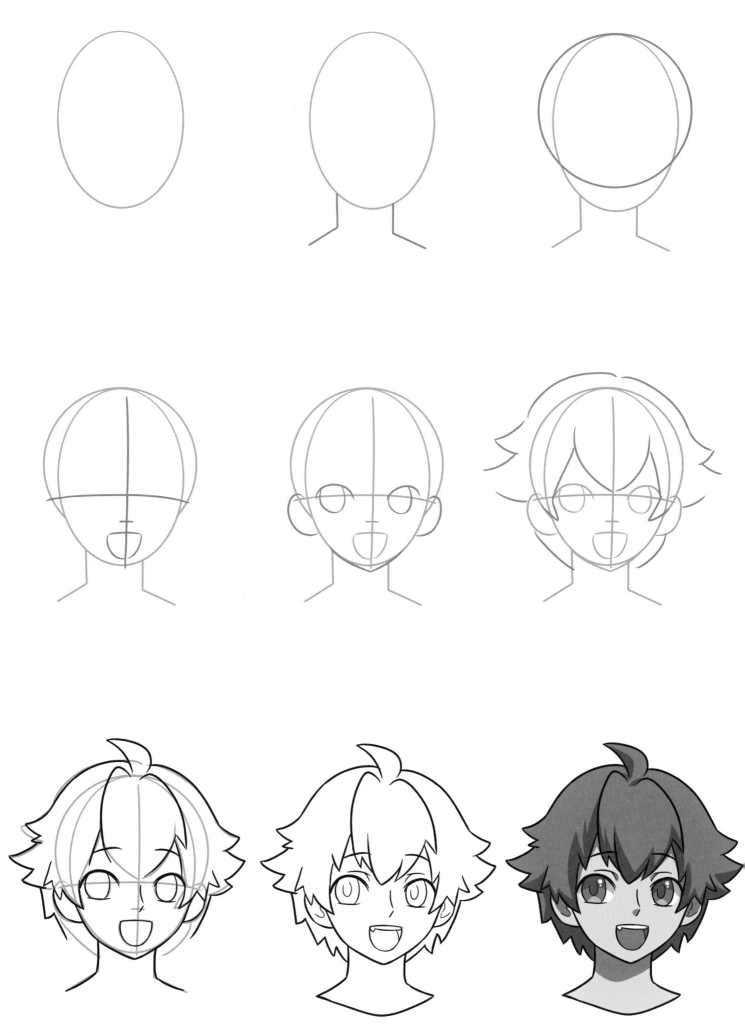

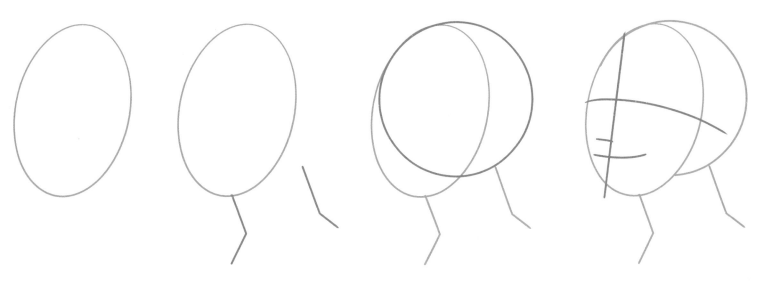

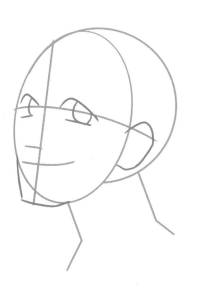
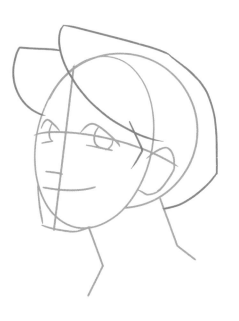
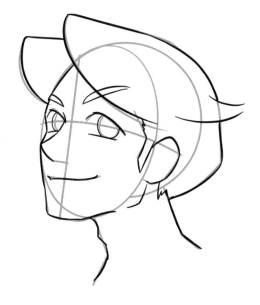

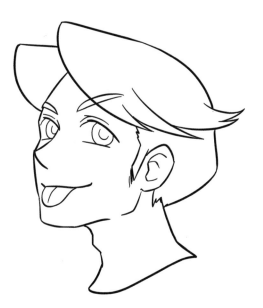
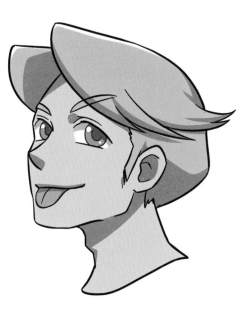

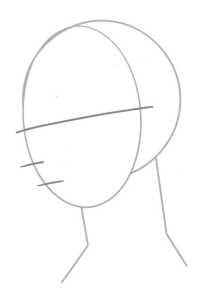
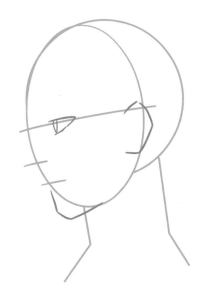
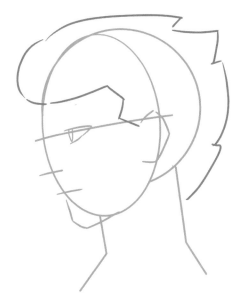
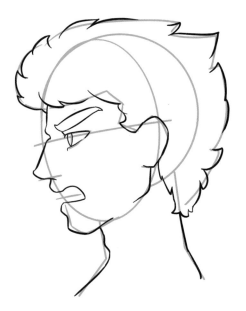
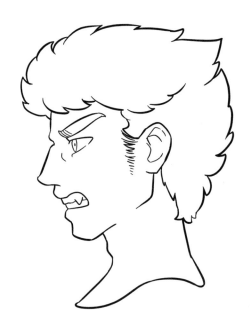
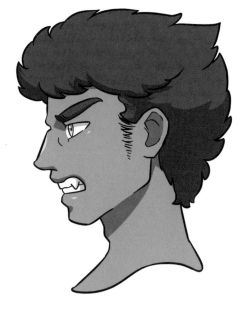